For the Love You Give

A Bark & Smile™ Book

Kim Levin and John O'Neill

**Andrews McMeel
Publishing**

Kansas City

To our moms

ISBN: 0-7407-2234-4

Library of Congress Control Number: 2001096530

Acknowledgments

As always, we want to thank all of the gracious dog owners for letting us capture their dogs' true spirit. Thanks to everyone at FotoWorks of Red Bank, New Jersey, for the quality prints that appear in this book. We would also like to thank Charlie, our dog, for the love *he* gives. Thank you to Patty Rice at Andrews McMeel Publishing for providing us with a great book concept. Finally, thank you to the many people who support animal adoption.

For the Love You Give . . .

I will keep you company on long drives.

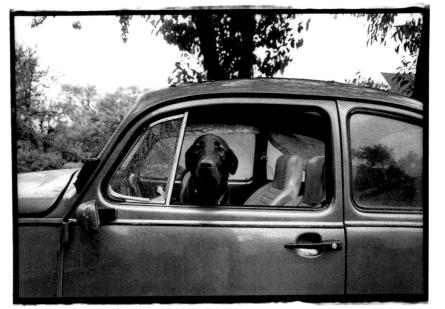

I will never stress.

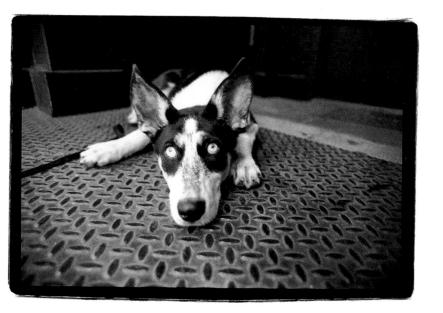

I will be your loyal companion.

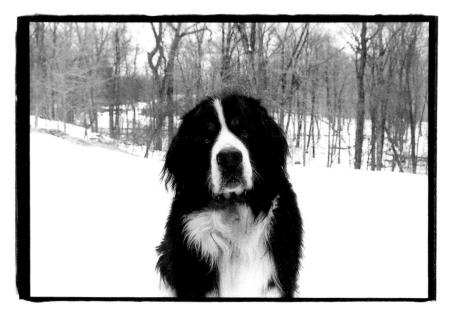

I will be the best watch dog.

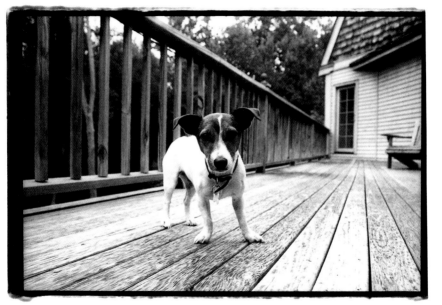

I will make you laugh.

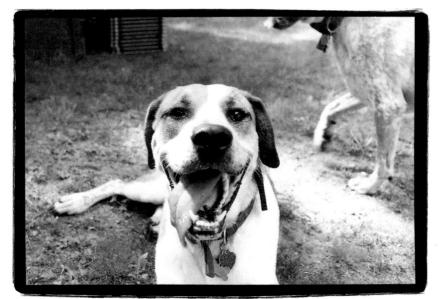

I will beg for food
(sorry, that's just the way it is).

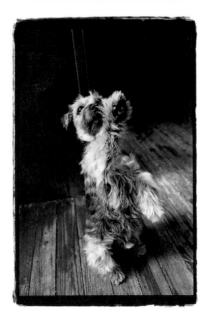

I will make myself at home.

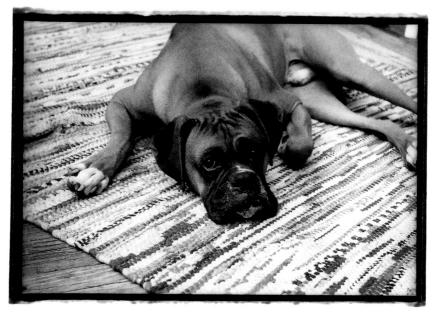

I will share with my friends.

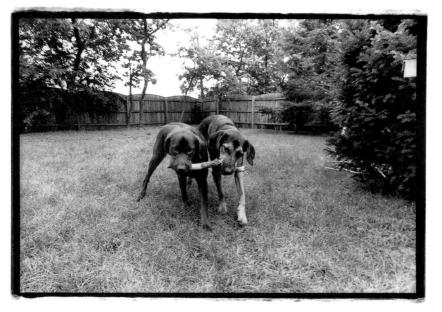

I will protect the cattle.

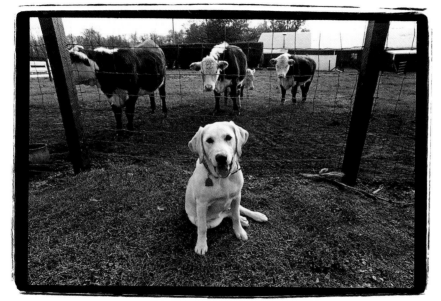

I will never (uh, rarely)

question authority.

I will always wait patiently.

I will love my brother.

I will be a good listener.

I will hypnotize you.

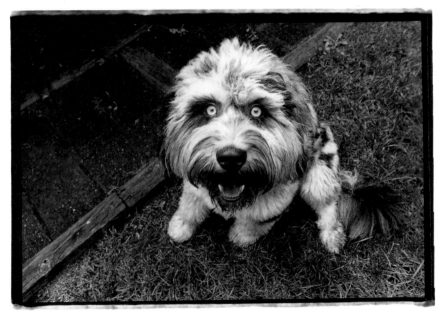

I will play fair.

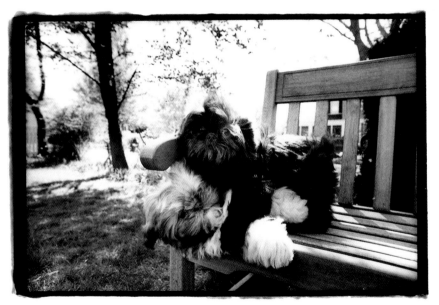

I will learn how to sit.

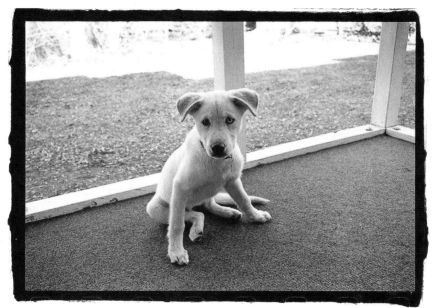

I will hold down the fort.

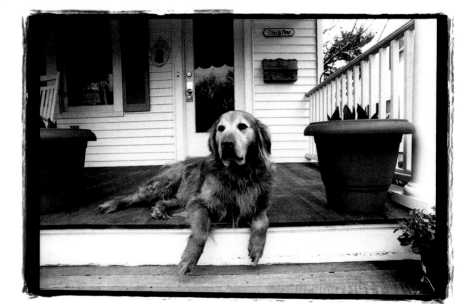

I will never say "good-bye,"
only "see you later."

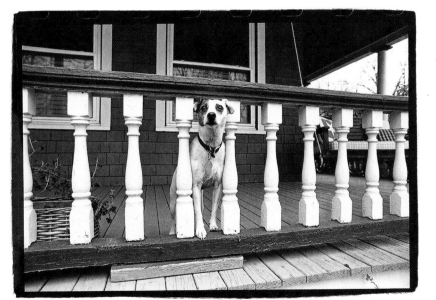

I will never take you for granted.

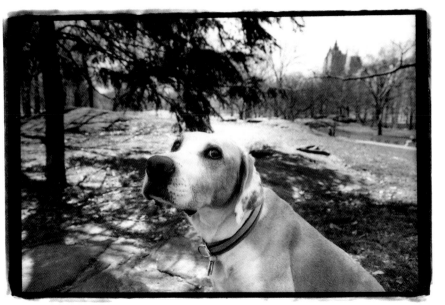

I will make you proud.

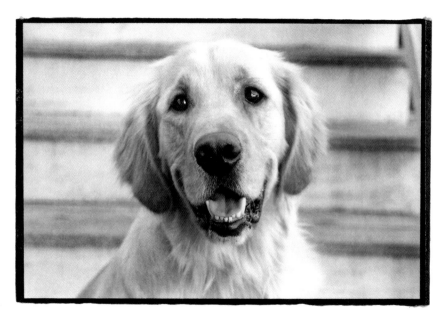

I will be on my best behavior.

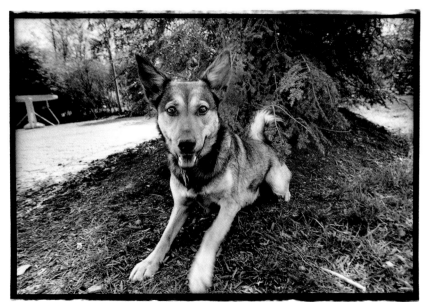

I will be chipper.

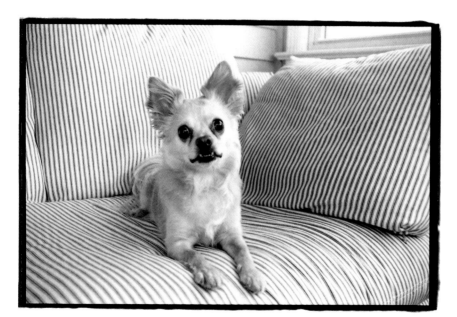

I will chase anything that moves.

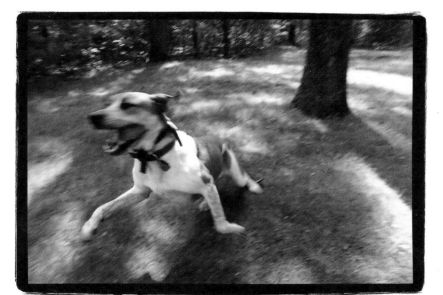

I will chew only my toys.

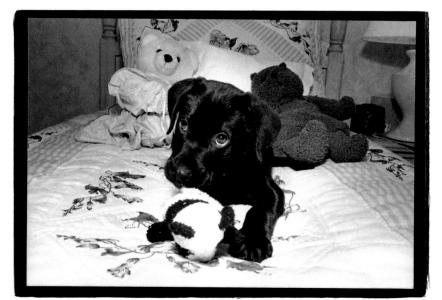

I will be humble.

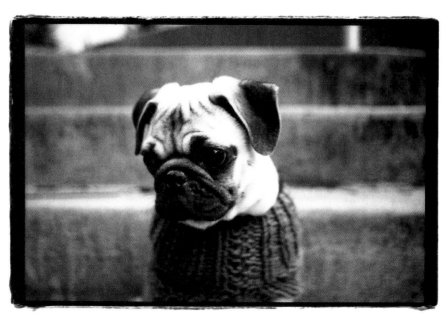

I will look up to you.

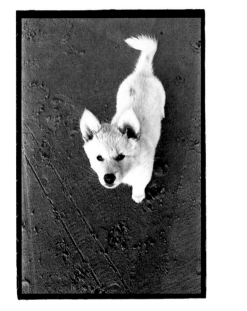

I will wait for your command.

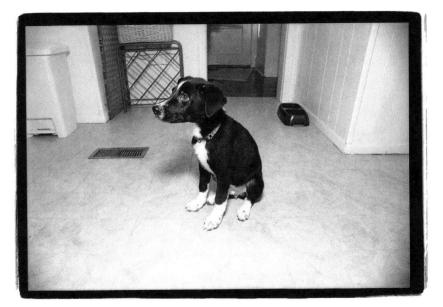

I will follow you wherever you go.

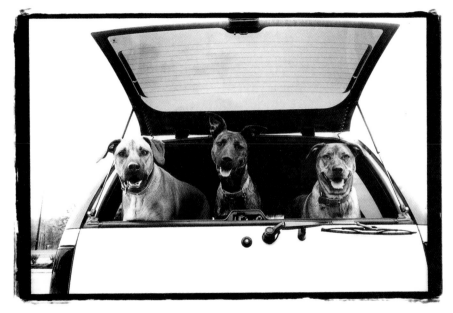

I will be your best friend.

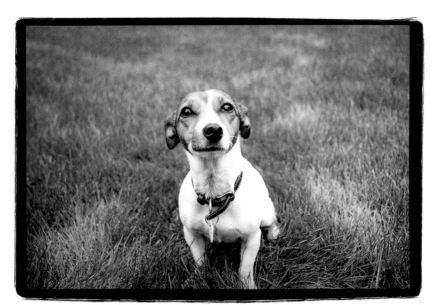

Other Books by Kim Levin and John O'Neill

Erin Go Bark!

Other Books by Kim Levin

Why We Love Dogs

Why We Really Love Dogs

Working Dogs: Tales from Animal Planet's K-9 to 5 World

Dogs Are Funny

Dogs Love . . .

Why We Love Cats